Breakdown

Kristen Kersey

authorHOUSE®

AuthorHouse™
1663 Liberty Drive
Bloomington, IN 47403
www.authorhouse.com
Phone: 1-800-839-8640

First published by AuthorHouse 3/15/2011

ISBN: 978-1-4567-1137-5 (e)
ISBN: 978-1-4567-1139-9 (sc)

Library of Congress Control Number: 2010918976

Printed in the United States of America

Don't Judge

I'm not to hasty because my
Thoughts aren't that tasty

For they leave me cold and alone
To wither

And yet some how this is
Oh, so bitter

Thus I daresn't judge for those
Amongst me are quite the same

Trying to put out their own
Bitter Flame

With out hints of shame
In the way of

Today

Life

Let go of your yesterdays

And

Worry about the problems of tomorrow

But

Why worry about the problems of tomorrow

When

You can dance

So

Why dance

When

You can sing

For

Life is full enough to live

Out

A long lost dream

But

Don't forget about your yesterdays

For

They can haunt you

In

our sleep

Then

You might have to be buried

6 feet deep

Because

The past is a horridness thing

That

Will seep from past

Into

A down fall of the future

More

As Life passed by, I always think of why, but as I see your face it all
becomes clear.
My reason of life is for you my dear, not a sound by your movement tells
me where you are, but in your heart.
I feel, hear, and see it beat, beat with tremendous love for me.
Love so uncontrollable it's a rush of adrenalin.
And then a down fall of hate from our very first date.

I love you, and you love me, but I'm not sure we should be.
I can't handle the downs of our fall.
By the end of the ride I can barley walk at all, but why would I want to.
If I am where you want to be, where I am loved and kissed by people on
their knees.
Why must I have more?
Maybe it's the lesser half I have and I'm in search of more, the better half
I could have.

More love.
More happiness.
More life.

Until then I lay here thinking of things,
while staring in to the blade of a knife.

My Dear

Please tell me what's true,
When I believe in you

What can I do?
When I'm apart from you

When I see you everything I know becomes clear,
For you are my precious dear

To find what matters the most
You'll have to look close

Close in your heart
Passed all the dark

The deeper you look
The more you'll find

Just promise me
you won't cross the line

People You Love

Where are the people that you love,
When you need them the most?

Are they too dealing with regretful ghosts?
That burry then 10 feet deep to watch them seep

Down

Down

Down

To the bottom of nothing
Event though they aren't quite dead

Just remember not only you
Are dealing with horrible

Thoughts of
Dread

Something More

There must be something more

Something more,

That I'm not looking for

Maybe something more than

This closing door

I'm sure there's something more

Something more than

What meets the eye

Time

Dreams are just like memories fading in the wind.
Another day forgotten before a new day can begin.

Days equals months, months equals years.

Years were to last a life time but now,
forgotten in a single second of an hour.

The breeze comes and goes with the flow of a stream,
Taking dreams away and hiding forgotten memories of the past deeper
into the dark.

Erasing everything in its path until yesterday seems like decades ago,
When it was merely a day away

Path Ways

This is a point in my life
Where anything and everything can
Change
Anyone of the four decisions can change me
Forever
Which path to follow?

Path One ~

Turn and free fall a million feet to my death
But I couldn't do that
Why not?
No one would cry
No one would miss me
No one would remember
No one would come look for me
Before taking my life of shame
I must see other paths of blame

Path Two ~

I could be with you
Forever until the end
But I really don't want
This to begin
Too much drama follows you around
And it leaves me looking
To the ground

Path Three ~

The path of continuation
Just go with the flow
Despite my personal insight
That cuts deep
Enough to make me weep
But just push it back
No matter how harsh the
Attack

Path Four ~

That will lead me to the door
Just to leave and not do a thing
No matter what comes my way
To run from day to day
Taking life's hard hit from
Day to day
Despite the pain

People

What's a lover with out love?

What's a writer with out words?

What's a teacher with out students?

What's a driver with out a car?

People
That's what they are, just plain Jane
People
Nothing more and nothing less
Take a person and shed them of their
Friends, Family, Surrounding, Clothes, Faces, Fronts, and Skin
What do you see?
Look past all the sin because that's always within
What do you see?
What don't you see?
Are you looking?
Are you ready for the truth?
Cause there it is… Nothing hiding it from you

A fool would poke around and get inside of the person
Analyzing each and every single piece
Judging as they go
A wise man would glace in yet another direction and
Simply walk away
For they have accepted the person as they are and will be

Yet, who's to do the same?
Who's to help the lame?
Who's to provide…
Love,
Words,
Students,
Cars?
For the building shame in everyone's heart
The real question is…

Who is to lead them in the dark?

I Want To Go Home

Thy wants to return to thy dwelling, but
Thy is at thy dwelling.

I want to return home, but
I am home.

Thy is confused. Why does thy feel in a foreign place,
Rather in thy dwelling?

I am confused. Why do I feel like I'm in a foreign place?
When I am at home?

Thy fortune will carry out to thy destination

My future will lead me to my home I long for.

Seize the Day

Today he is fine with out a single trouble

But as times flies

And age grows, no one has the promise

Of tomorrow, so off he goes

A new adventure is

A start of a new day!

Happy

I am so happy right now
Even though no one on planet Earth cares

I think I am going to scream a happy sound
For all to hear around
In this small unhappy town

If I could just scream
Wow!
I think I could find my way
With out place to stay
And
Alone every single day
Yet I still need some time to play

My happiness was extreme
Like a natural high
Picking me off the sky
Maybe if I try to fly
I won't die

But it is gone
Just like me
Not to return
But to be
Gone until dawn

15

A Letter

Remember when we used to be in love?
Yeah, those were the good times.

I thought it could last forever,
And end never.
All things end as they do begin.
Also I will admit this letter has been planned out
And
Written ahead a time because
I, I've been thinking of things to say to make it seem okay.

The truth is, is that it isn't okay, and won't be.
This letter isn't to fight with you;
I've done enough of that,
And
I don't see sensible reason to continue
This never ending fight of,
Who did what,
Who hurts more,
Whose fault it was,
Who left who.

In the end it isn't worth it,
You're not worth it.

And I've talked to many people of what to do,
With us

Where should it go?
What should I do?
What happened to what I used to do?
What I used to know.

I will admit,
I miss you,
I miss talking to you on the phone,
I miss the comfort of knowing
I wasn't alone,
I miss all of those things we had that I've never had with anyone else.

It has gotten to the point
Where I wonder if you even read everything I send you,
And if you think it through

I take the time to write it; it's the least you can do.

The whole point of this is to say good bye.
And I love you,

And you say you love me,
But what kind of love is it when you don't text but once
In three days
When you know
"The Best Thing You've Ever Had"
Is leaving?

I don't know what it sounds like to you
But to me it sounds terribly wrong.

That isn't the matter of the subject here,
Now is it?
Nope,
The only question is why?
I mean you wanted to give them a chance,
And that you didn't want to hurt them,
But that meant sending me to hell.

Did that matter?
Why?
I think to myself every day,
And the never ending question is why?

What made you?
Did you want to move on?
I just want a reasonable answer,
And sorry for bothering your life; it seems to be going just fine with out
a word from me.

I mean why even bother, but I just want to know why, then to say good
bye.
All I ask of you is an expectably reasonable answer to why.

Rainy Day

The rain drops though a broken window.
Breaking all the rules and being untamed.

First Drop,
One tear travels down my face.

Second Drop,
Clears the fuzziness in the memory that cuts deep into my heart

Third Drop,
Completes the flood of tears on my pillow

Fourth Drop,
Brings a small amount of hope that tomorrow might bring

Fifth Drop,
The end of all tears because there are no more to be shed.

I turn my pillow over and get rest because
Tomorrow is going to be another rainy day.

Silent Depression

I hold my head high,
For no one's to know I've died.

Inside it's dark, cold and lonely,
While I walk slowly

Thinking to myself how can this be
What's to be come of me?

When people pass, I smile
As if nothing has happened,

The world still turns
And the sky hasn't fell
I've only gone to hell

But no one knows I've died,
Because I hide from the darkness inside

You Are the One to Blame

You are the reason for,

Every tear I cry,

Every break in my heart,

Every time I'm angry,

Every time I'm sad,

Every emotion I have,

And it's all revolved around you,
I mean what can I do?

Dead

There is a whole in my heart
It is DEEP and DARK
It tears me apart.

The depth grows in size
Making me despite all of your LIES

The darkness is pitch BLACK
Carrying me back
To the MEMORIES that
Stick to me like plaque.

I FIGHT day after day
Trying to find a way
To say what will keep you AWAY.

It would take a simple GUN to the head
Then I'd be DEAD
Never to be wed
Not even a TEAR shed
For my lonely, lonely empty head
DEAD, not a single person FLED.

DEAD comes with tremendous amounts of
Dread that fills my
Head to the
Brim with SIN.

Sin, like a long **LOST** kin
Hiding me under its fin
A fin of a serpent pulling me in
And **STABBING** me with a pin

So I **RAN**
Ran to an open hand
Not knowing the plan

For you can be like sand
Pulling my hand **DEEP DOWN** to **DARK** lead

KILLING me until I am completely
DEAD

Rock Bottom

My hands are shaky
My feet are unsteady
My head is dizzy
 I'm striving to walk straight
My face feels hot
My eyes are on fire
My breathing is shallow and fast
 I can't calm my racing heart

 Then
 The
 Bottom
 Falls
 OUT

 And the tears come
 Fast, cold and heavy

 I have no where to go
 I have no where to hide
 My temperature is on the rise
 And
 I have completely died inside
 I'd rather be six feet under to escape the
 PAIN

 I've fell to the bottom
 A bottom so low

I'm shaking so horribly, I can't stop
I'm so unsteady, instead of trying to stand up, I lay on the floor
I'm so dizzy the world won't stop spinning
My attempts to walk have failed each time I try
I'm feeling my face deepen in to a darker shade of red
I'm patting my eyes in hope of soothing the burning pain
I'm striving for calm, slow, deep breathing
My heart has completely stopped.

Is this what it's like to be dead?

Alone
Cold
Dark
Dark
Darkness
Over whelming darkness
Fills my life to the brim
More now than ever

Lower than low is currently my status quo

I've hit rock bottom
And there I'll stay

Until another day

Far, Far, Far Away

This is driving me **insane**

I'd rather **crash** into a plane than to
Go day to day

With out word
With out glance
With out meaning
With out you

I'd rather lay here under the stars
Instead of a million bars
Just to see you **crash** in to a car

Far, far, far away
Like a distant day
Far, far, far away
With **no** play

Far, far away **space**
Will **kill me** before the day of yesterday or
Perhaps tomorrow
Washes in to my life

For the fabrication of my very existence is made up of
Death
Far, far, far away death
Peaceful death

To take me away
So flying is possible in my time of today
To **fly**

With out you
With out meaning
With out glance
With out word

I hope this to be true
To make my **quite escape** from
You

A Story to Tell

Time to tell this story very well for it is truly is a long story to tell
I miss how we used to be
And you will see when all else fails
I will uncover my veil

I have always been here and
Here I will stay
For I'm terrified to move away
In hopes of your return

If you ever return
I hope you'll stay
But at my dismay
Nothing goes as planed
Because of the reality at hand

Yes,
I hope for thing to be different
Yes,
I do love you

But
Not one know for it's because of my enemies and foes wind together
with robes

Bye, Bye Love

Roses are Red and
I am feeling very blue

Because I haven't seen you

I am moving on because
Our love is gone

I Am Lost

Maybe two is better than one,

 But be careful of what you will become,

For loves toll on a heart,

 Might just break me apart,

My word is true,

 For I've felt very blue,

I've been blue because of you,

 Now to be honest I don't know what to do.

Something Is Missing

I don't know what it is
But something is up
It's just not the same

I don't know why
I don't know who
I don't know how
I don't know what

And how am I supposed to know where?
When your not there

I don't understand
Why aren't you there holding my hand?

Where have you been?
Since God knows when?

All I know is
Your not here
You're somewhere I'm not
With out me you are
With out you I am

Lost in the time of sand

Everything

You are my everything

Your eyes are what hold mine to you

Your smile is what takes my breath away

Your thoughtfulness is what steals heart

Everything about you makes me

Love you more and more

Every single day!

Don't You Know

What in the world is your problem?
Why can't you see?
Why don't you see?
When I make it in plain sight?
If I didn't love you,
I would give up but,
I do love you so,
I can't move on.
I just hope and pray
That we can be
Together
Forever
One day.

A Gift

A soft hand's caress
Upon your magical dress
A soft hand's caress
Upon your gentle face
A soft hand's touch
Upon hair of gold
A princess,
You must ask,
Not indeed, but a commoner
About to share a special gift
A gift of love
A gift of happiness
A gift of a simple
Slight kiss
A gift is a gift
Just as
People are people
But joined together can make something
To remember
For a decades life time

A Simple Thought

As summer fades and fall blossoms,
I picture what it would be like with you.

My face would be filled with joy.
My heart with be filled with love.
My eyes would gleam.
My breath would stop every time I saw your face.

Oh! What is happing to me?

Why must I think these regrettable things?
When I know it will never be this way because
The one I love the most won't see,
And he won't even think twice about me.

Days of Our Love

Day one
Love at first sight takes over
Day two
I want to be with you
Day three
We are meant to be
Day four
You keep shutting the door
Day five
I am losing my mind.
Day six
This cant be fixed
Day seven
This is the end of the line,

Can You Stay

Oh Thy love for ye is great
Ye has come and
Ye has go
Thy shall not be fooled
Shall ye say or
Shall ye go?

Lovers

You love me oh so much
And
I love to feel my lovers touch

Weather we are together
Or far apart

No matter what you're always in my heart
Not a day goes by
Where I don't miss staring in to your amazing eyes

I can feel you miss me too
If only we knew what to do

We've had our
Ups and downs,
Our
Wrongs and wrights,
Our
Lefts and rights,
And
Our fights
That are followed by delights

We are close together
In fact it's as if we are one in the same
Our love is the one to blame

Together

Here you are and
Here I am
Together holding hands

I love you and you love me
Together for entirety

He is mine and I his
Together we belong

You and me here tonight
Together forever

Our love is great
Forever without escape

Wound together with something stronger than tape
That makes our love's shape

You are there for me as I for you
Together we are

I know for a fact this
Must be right
As we are together till the end of time

You & Me

You
And
Me
Here tonight

Together
And
Forever it will be

I know for a fact this must be right

You

Inside it is too much to bear.

Outside no one cares.

But when I see you nothing matters.

Because I know I am with the one I love.

I Wish

I wish it was us.

I wish you could see.

I wish you would know.

I wish I could be what you want me to be.

I wish she wasn't there.

I wish I could erase her out of the picture.

I wish it wasn't this way.

I wish I didn't have to go.

I wish you know my love for you.

Is This a Game?

Pick a boo, I see you.

 1, 2, 3 look at me.

Hide and seek around the tree.

 This is a complex love game
 For you and me but

The question is
 When will it end?

$\mathcal{U}s$

He is here forever

 Yes

He is mine and I his

 Together we'll be forever

Truthful Love

Ye pots said to Thy potter

Do ye know nothing of that,

Which ye speak so commonly of?

Of this… this forbidden untamed love?

For affairs of thy heart must

Be truthful to thy soul and

Shall be true from

From past, to present, in to future

Forevermore to come

<u>*Love*</u>

What do you call this?

This …..Overwhelming,
Overpowering

This feeling you have for someone else

It is called real, true,
strong love

Love Grows

Thy see ye on a row

Ye proclaimed Thy thoughtful name

Thy which became wordless

Forevermore

Ye love has grown

Love Is Love

A boy

 A girl

Two different

 Worlds

Two different

 Families

Two different

 People

They meet and sparks fly uncontrollably.
 Differences don't mean a thing.

 Their love is so strong that
 They will be in twined for eternity.

Love Is Needed

Love, Love, everywhere
But no one to love ye

Love, Love, in the air
But none to keep for thy heart

Which is in a great need for thy to survive

Our Relationship

You asked me
I said yes

You said no
I said I have to go

You said I love you
I said I wish it was the same for me

The Truth

A simple car ride in the spring time,
On the way to my house
Turns in to the moment of
Truth

Just playing around, I take your phone
I look at your messages,
This simple glance at your phone for a short second,
Turns in to the moment of
Truth

I am shocked in amazement,
To the point of my silence and build up of tears
I can't believe this is the
Truth

I pretend not to notice,
I pull this off successfully
Later that night,
I ask about the
Truth

You shrug it off,
As if it was my imagination
Doesn't the word love mean something?
If I doesn't, I guess I didn't get the memo
This is the
Truth

Why must you lie?
You have forgotten your lies
I ask
You tell yet another to cover up your
Recent memory loss
Why are you hiding the
Truth

Your lies are repeated
Over
And
Over
And
Over
Until they all become a simple blank blur
And
I really
Just
Don't
Care
Anymore

The truth broke my heart,
But it at least It was the
Truth

Cheater

A down poor of tears covers my cheeks
This is the second time
Don't even pretend you don't know your own deed!
I saw you and her….I saw ya'll together
You gave her my love and
You told her what you always told me
To bad I couldn't see before… because
This is the second time you've cheated on me

Her

Why is she here? What has she done?

What, What is happing? I saw her with you.

Flirtatiously ya'll met and flirtatiously she went
Flirtatiously... it is becoming too much of a burden

For me to even began to bear
Here she is and now I leave

She Took You

We were stronger than ever
 Just you and me together

 But then she came and
 Ripped it all away

 Now I am stronger than ever

Even though we aren't together

Tall, Tall Tale of Lies

Gentle hands belong to steady feet for those to meet and greet

Time and time again I heard you to be my lawful FRIEND

Friendship grows into courtship that will be amongst your wildest
DREAMS
That is except for you and me
TOGETHER WE WILL NEVER BE

A story told with tall, tall tales and hushed sorrys play a role into the toll

A toll of which meanings of words don't lie, but
Then take a DIVE into the deep dark loneliness of
The SKY

The flair that started a FLAME
I mean who's to BLAME?
For this awful, awful SHAME?

Other people come and go with the passing of
how-do-you-dos?
And hellos
But only one is the reason for what I've
BECOME.

See, when two became one

Our
LOVE
Was
UNDONE.

You became **CLOSE** with the passer-bys of our ties

Then **SORROWS** became my **FRIENDS**
UNENDING with inequalities at amends
Then I found out despite all my **DOUBTS**,
That was **TRUE**,

You **NEVER** wanted **ME**
And
You **NEVER** had a **CLUE**.

For the glue is **DRY** and the story has **DIED**
I mustn't go on about this **TALL, TALL TALE OF**
LIES.
For it has become my **WEAKEST DISGUISE.**

Why Aren't We Us

Our bond was stronger than ever
We were inseparable
You had me at hello when we met
I had you at three letters on a note
That you gave me
I loved you
I thought you loved me
What happened?
Was it me or was it you?
Unfortunately, this I will never know

The Past Few Days

The past few days have been taking a toll on my depression
My life has been put in to a permit…
Recession

These few last hours have been tearing me
APART

I can't run, hide, duck, or escape the truth,
No matter how much I hate it

Was it something I did?
It had to be

What have I done?
What the hell is wrong with me?

HER

Yeah, that's my problem

HER

You lied,
Yes, you did.
I wish I was gone
I wish I hadn't
If only,
Oh, how I wish

Please, Please, Please
Why?

What does she have that I don't?
What does she do that I don't?
What does she say that I don't?
What must I do?

I must
GO
And never look back

I can't
I won't

Oh, God help me
I am ten feet deep
And
Over whelmed
With a saddened
Depression
And a burning passion
That brought me to my
DEATH

I don't know what to say
I don't know what to do

I am so clueless

With or without you

So do it! Go ahead
Make your choice
Me or
HER

I'm shaking and going blind

I DON'T CARE

Just go, just leave, just…, just

I DON'T KNOW

Lose me and love her
Love her and love me

It seems as if this is a one way street
Destin without retreat

I won't turn back, I wont move on

I'll just pull over and sit alone

FOREVER

But wait,
Maybe

I can drink these tears away
And
Get so drunk that I can just run
From
My fears
And
NEVER
Have to stay in one place for years

Maybe I could pack my bags and leave town

For these past few days have been the worst known to mankind

My Dad

You're big.
You're tall.

You're strong.
You're not afraid of anything.
You take care of me the best you can.
You make me happy.

You care about me.
You love me.
You are my one and only dad.
And

I love you!

Are We Really That Different?

People
Humans, citizens
Loving, caring, hoping
Careful, thoughtful, hateful, harmful
Thing, varmint
Animal

Beautiful

Being kind with in and beyond the heart

Elegantly displayed

Appealing beyond all means

Ugliness is no where to be found with in the heart

Taking everyone's attention

Ideal your personality will be

Fascinating you will become to many

Unattractive other's jealousy will be

Luxurious will forever more be your image

 Beauty comes with in and shall not be foreseen by image.

Best Friends Forever

You are there for me and
I am there for you
This isn't boy, girl love as it would seem
But this is the love of best friends
More like sisters we should be.

Him

Him
Tall, Strong
Becoming, Working, Welcoming
Oh! How thy love him
Love deeper than thy own good
For thy don't diverse such a man like this
He… which has no name

Rain

R ~ Rebellious for reason of uncontrollable times of event

A ~ Aqua rolling down your face or free falling from the sky

I ~ Idly setting on he top of a pillow, or on the bottom of the Earth

N ~ Noble are those who get cut short of rain, but still make it through the day without suffering endless pain.

What's The Point?

What is the meaning of tomorrow is there is no today?
What is the meaning of today is there is no tomorrow?

What is the point of living in the moment with out a second?
What is the point in living for tomorrow is there is no future?

What is the point in life it's self?

I do wonder, but I don't care to find out.

I'd rather just sit here with loads of doubt,
uncertain of what this is all about.

Surreal Event

Today I will walk alone
Along this very long road

Each step I take is another place mistaken by sight
Until night falls then everything becomes clear

Especially between us my dear
I'm sorry but I can hear, its just id rather not listen
Listen to your repetitive lies

And you know how much I despise this
One day when the end is here

You and I both will be in tune with the basic elements
So that reality slips away just as fantasy will be come real

Life will seize to exist beyond this surreal event.

Waiting

After everything I'll still be here waiting
Thinking of you every day and second as I wait
I will only hope to see you in our place

Our place in your heart

Our place in my heart

But until then I'll continue to wait
Just please, I beg of you, to tell me of your return
So that I will be blessed with the words to stay
The words to say that will make you want to stay

I Love

I love the way you love me so much
I love your thick dark hair
I love your amazing eyes
I love how you make me feel better
I love your tan skin
I love your tall shaped figure
I love how you're older than me
I love that you always want me

But even though I love you so very much

I hate how we never talk
I hate how you work
I hate that we cannot see each other
I hate that I am so young
And most of all I hate that I really
don't know you inside and out

The worst part is your absence in my
life is killing me with vast amounts of
pain

Forever Gone

One last breath
A lover's sweet kiss

<div align="right">

Takes me away
Lifts me up high in to

</div>

The night sky

<div align="right">

Yes, I do wish to stay
No, I won't say goodbye

</div>

For you I'm gone
This had been going on
Way, way, way to long

To bad I can't sing
You a sad, sad sweet song

Maybe I could to see you
And take your breath away

<div align="right">

Sorry, but I'm forever gone

</div>

Not yet to stay

Revenge

Terrified beyond all reasonable doubt
 If only I could shout

A shout of emotion
 A shout of pain, sorrow, sadness, and most of all anger

You said I shouldn't have but I didn't see the danger
 Dangerous danger that's extraordinary lethal

All I do is grin and bare it
But I do hope to share it

 Share it with you that is…

Moving On

I have to move on
Despite your deceiving words

You never do as planned
I would stay because I love you so

But I'm sorry I must go
For all of these lies, actions, and words

Have been building up into a ball of hurt
A ball of hurt that rots my heart

I would like to sit alone
In the **_dark_**

Your Name

I sit in the corner
　　　　Where it's dark and cold
　　I want to be alone
　　　　　　　　　　Because of fear

I walk by myself
　　　　Because I can
　　When I hear your name
　　　　　　　　　　I scream with pain

I can't forget
　　　　It goes to deep
　　When I get home I sit on my bed
　　　　　　　　　　Then I sink and surrender

To the grounds up reach

I Loved You

I have always loved you from the start

But you keep pounding on my heart

I end up left in the dark

Why must you do this to me?

I would have known but
I believed you this time

Shame is mine
I didn't see it coming
But

Here it is

My only question
How fast can I make it…

End

This Sad

The first tear flows

How cold you do this to me?
I run to the bathroom

My next message awaits me
I lock the door

Oh God! I gasp then hit the floor
More tears come

What did I do?
I begin to lose my breath

I know I love you
But I thought you loved me too

I'm shaking like mad
How can't I be mad

When I'm this sad?

The Pain

The pain cuts deep

I wish I wouldn't feel your absence that
Sucks my life away
I wish I wouldn't see the words in black,
I want to go back
I wish I wouldn't hear my gasp for air,

It's very unpleasant even for you my dear

I wish I wouldn't taste the snot running from my nose,

Lucky at least it can escape

I wish I couldn't still smell you in the air,
The empty air
To bad your there and not here

For I am shaking cold and all alone

Anger

The pain is enough to kill
 It sends out a high pitch shrill
 It forces a gasp for air
 Besides the snot running down my face
 My lips are dry
 Because of deep breathing
I'm trying not to die
 It hurts
 Yes
 It hurts oh so bad
 But yet some how to you
 This isn't sad

 I can't believe you think
 I'm mad

You Don't Care

Thy have embraced the thought that thy cant do this any longer.
Yet

Ye is as clueless as a cat herding sheep, so clueless that ye is a
complete fool not to see thy
Attempt to hide behind a
Mask

Thy mask has been removed but Ye remains to be the silly
foolish cat herding sheep, clueless and oblivious to the extreme
extent not to see thy changes have been vast.

Then
Thy puts the puzzle together to see that ye, the silly cat
herding sheep, didn't care, and most likely never will

Sane

Shower me with love
But don't give me hugs

Shower me with kisses
But don't share with delight

One fight tonight
One fight today

One fight tomorrow
One fight in the night

Hurts my sorrowful pain
With absolutely no gain

I'm not sure
How I stay sane

Sometimes

Sometimes I wonder why,
Why do I even try

Sometimes I want to die,
Die eye for an eye

Sometimes I want to fly,
Fly so very high

Sometimes I want to fall,
Fall a million feet in the air

Sometimes I wish I didn't care,

But I know I cant help but do.

The End

The end is near
I'm sorry my dear
Despite all of this building fear

With tear after tear
I honesty don't think
I could go on another year

The end is near
There's all this fear
Tear after tear

What shall I do my dear?